Touris

\ 1

CW00521925

Vara

Cuba

**Access the World with
this Essential Guide to Accompany You
on Your Holiday
to**

VARADERO

1st Edition
Brian Smailes

Challenge Publications

First Published 2003
ISBN 1-903568-08-0

Published by Challenge Publications,
7 Earlsmere Drive, Barnsley S71 5HH

Acknowledgements

I would like to thank the following people for their contribution to the compiling of this book: -

Gillian Duckett (Photography) for the superb photographs on plates 2,5,6,7,9,11,12. which portray the country so well.

Nicola McGill, Michelle Fleming, Thomas Cook Tour Operations, (Bradford) for the valuable assistance and advice from start to finish.

You will never walk alone with these books published by
Challenge Publications

Other books by the same author: -

THE SCOTTISH COAST TO COAST WALK
ISBN 0-9526900-8-X

THE GREAT GLEN WAY
ISBN 1-903568-13-7

THE COMPLETE ISLE OF WIGHT COASTAL FOOTPATH
ISBN 1-903568-08-0

JOHN O'GROATS TO LANDS END WALK
ISBN 0-9526900-4-7

THE NATIONAL 3 PEAKS WALK
ISBN 0-9526900-7-1
Also on CD

THE 1066 COUNTRY WALK
ISBN 1-903568-00-5

MILLENNIUM CYCLE RIDES IN 1066 COUNTRY (EAST SUSSEX)
ISBN 1-903568-04-8

FIRST PUBLISHED 2003
CHALLENGE PUBLICATIONS
7, EARLSMERE DRIVE, BARNSLEY. S71 5HH
ISBN 1-903568-08-0

www.chall-pub.fsnet.co.uk
E-mail challengepublications@yahoo.co.uk

Brian Smailes

Holds the record for the fastest 4 and 5 continuous crossings of the Lyke Wake Walk over the North York Moors. He completed the 210miles over rough terrain on 5 crossings in June 1995 taking 85hours and 50minutes.

Brian lectures on outdoor pursuit courses and between these travels extensively on walking expeditions and projects around Great Britain.

Long distance running and canoeing are other sports he enjoys, completing 25 marathons and canoeing the Caledonian Canal 3 times.

His most recent venture involved cycling from Lands End to John O`Groats in August 2001, a journey of over 900miles in 6days 13hours 18minutes. This involved carrying food, clothing and tent, and was completed without any support between both ends.

Having travelled extensively around Great Britain, Europe and the Caribbean, Brian is currently writing international travel guides to enable the holidaymaker to access the world with ease and enjoy it as much as he does.

Contents

Photographs

Page

Sketches

The Island of Cuba

Cuba is a jewel in the crown of the Caribbean. An island situated in the Gulf of Mexico and lying 110 miles from Florida. Discovered by Christopher Columbus in 1492, it is the largest of the Caribbean islands. Havana (La Habana) founded in 1519, is the capital and seat of power to Fidel Castro.

Havana was described as the finest city in the Americas with its colonial past, architecture, squares and forts *(plates 15-16)* it is also the largest city in the Caribbean. Old Havana or La Habana Viejo was a stopping place for treasure ships laden with gold, on route to Spain.

Over the past decade the former links with the Soviet Union have crumbled and now Cuba is looking to other ways to boost its economy and one of them is tourism. This is now a fast growing business in Cuba.

Cuba is an island of vibrant music, palm trees and white sandy beaches *(plates 9-11)* a place which will leave a lasting impression on your mind with its culture, rhythms and architecture, the coconut palm fringed beaches, and lush tropical vegetation.

Each town and city in Cuba has a tale to tell of pirates, Indians, slaves or the revolution and the people of Cuba with their music and friendly welcome add the spice necessary for that mystical and unforgettable holiday.

Some initial facts about Cuba: -
Total Area = 110,900 km^2
Longest River = Cauto 370km
Highest Mountain = Pico Real del Turquino 1,974m
Population = Around 11 million

Map of Cuba

The Varadero resort is shown, also Havana and Trinidad.

Brief History of the Island

Originally Indians colonized the island as early as 4000BC up to the 16th century when the Spanish came along and decimated the inhabitants. Christopher Columbus visited the island in 1492, then over the next century various Spanish conquistadors exerted their influence and the Indian population slowly continued to decrease.

The Spanish searched Cuba for gold but realizing there was little to be had, turned their attention over the years to farming and the cultivation of coffee, sugar cane and tobacco. Spain generally kept possession of the island but in 1762 the British navy took possession for 11 months before returning it back to Spanish control.

Over the next 150 years various uprisings of slaves and other infighting resulted in the deaths of many people.

Pirates from around the world had brief stops in Cuba to tend their ships and restock with provisions.

America took control of Cuba in 1898 before giving it independence soon after. In 1952 General Batista carried out a military coup and took control, but many people became disillusioned. Eventually Fidel Castro joined with Che Guevara to lead an attack on a barracks in Santiago de Cuba. This failed and Castro received 15 years in prison. He was released after 3 years and exiled to Mexico.

In Mexico, Castro again met Che Guevara and from here he planned then led an attack against Batista, which turned into a revolution. Fidel Castro came to power in 1959 and has remained since. Although declaring Cuba a communist state, Castro has gradually softened his approach and now encourages tourism as a means of helping the economy.

Although the U.S. severed all links with Cuba back in 1962, it has continued to survive and operate independently especially since the collapse of the Soviet Union. Many items are still rationed for Cubans, but life is gradually becoming better.

Travelling around the island generally and in Varadero you will see many 1950's automobiles *(plate 2)*. These are a left over from the days when America traded happily with Cuba and cars were in full supply until the links were cut. Spare parts are hard to find now, but the cars still keep running and are an amazing sight for the tourists who admire and photograph them wherever they go.

When travelling around Cuba you will see many statues, and slogans on walls commemorating the revolution and Che Guevara. He is regarded as a national hero with songs written, banknotes, t-shirts and other memorabilia with his figure on them. His mausoleum *(plate 17)* has an eternal flame as a tribute to him, in the town of Santa Clara.

Geography of the Region

Cuba is an island approximately the size of Britain, but it has over 4000 small islands or 'cayos', stretching along its northern and southern shores. To the north is the Atlantic and to the south The Caribbean Sea.

The city of Varadero, established in 1887, is situated in the Province of Matansas and is the main resort on the island, covering over 15sq. km. The capital Havana is within travelling distance being only 86 miles/140km west of Varadero. The city of Cardenas is 16km to the south west of Varadero and was the first city to raise the Cuban national flag in 1850.

The Varadero resort is a flat plain on the Hicacos Peninsular, which extends for 12 miles between the Atlantic and the Bay of Cardenas to the south. It is Cuba's most northerly point. The beaches are generally white in appearance, with the sea a turquoise colour. This helps to make the Varadero beach one of the most famous in the world.

Access to Varadero is by crossing a bridge leading onto the peninsular where the autopista can be joined, which is for the most part a dual carriageway and bypass leading to the far end of the peninsular. All hotels can be reached from the autopista, as well as the main shopping and residential area. There are at least 40 hotels on the peninsular spread from one end to the other, with more being built each year.

The streets or 'Calles' as they are known by, in the residential area are numbered 1 – 69 and start just over the main bridge extending a third of the way along the peninsular. The main activity, daytime and evenings, centres on 1st Avenue and the old town area between Calles 23-64.

Towards the far end of the peninsular in the Bay of Cardenas, is a large area of mangroves just off shore. This is an interesting place, which can be further explored on a tour, (see section on places to visit).

Tourism in Cuba

The past 10 years has seen a transformation in their economy from production of sugar, coffee and tobacco to tourism. This continues to grow, as the main holiday areas around Varadero, Holguin, Cayo Coco and Guardalavaca area are developed.

Cuba has been quick to seize the opportunity to establish itself as a holiday destination with countries such as U.K., Canada, France and Germany who collectively send approximately 2 million tourists to this part of the Caribbean each year.

Colleges and training schools where Cubans can learn about tourism and the hotel trade are thriving. Local people from Varadero, Matansas and Cardenas gain employment in the hotel industry and provide a good service in catering, hygiene and general hotel work. The standard in all the hotels I visited appeared very high and I was impressed by the professionalism of the staff.

There are four main tour operators within Cuba, Cubanacan, Havanatur, Gaviota and Cubatur. In the Varadero area I found Gaviota and Cubanacan the prominent tour operators. Their guides could speak several languages and the tours that I participated in were well organized and of a high standard.

The web site for Cubanacan is: - www.cubanacan.cu

The People

Cuba has a mixed race population. The majority of people come from Spain, Gambia and Nigeria along with some from other parts of the world. Around 30% are black with 65% being of European decent.

The Cuban people welcome tourists, not only because of the trade and income they generate but because they are genuinely interested in what happens in other parts of the world and want to make friends to find out more. I found them one of the friendliest people to meet.

Many Cubans can speak a second language, play an instrument and will be pleased to hold an intelligent conversation with you. There is only around 1% illiteracy on the island and all education through to the end of university is free.

Crime on the island is very low and I found it safe to walk out late at night around the Varadero area. Obviously do not tempt fate by walking around back streets late at night or flashing expensive jewellery and video cameras etc., as you would not do in most other parts of the world.

The population being of mixed origin, a number of religions are practiced including Protestant, Roman Catholic, Jewish and Muslim. There are a number of churches around and indeed some splendid ones in Havana. Generally there is freedom to choose a religion with the most widespread being Catholicism.

The Pope visited Cuba in 1998 and since that time the Cuban people have been allowed to celebrate Christmas when previously it was banned.

Language

The language of the Cuban people is Spanish but you will no doubt find that many people do speak or have a basic grasp of English. You will find that especially throughout the Varadero area you will not have a problem being understood by most people.

You may find it helpful to be able to speak a few basic words in Spanish, e.g. how to order a beer, good morning /afternoon etc. and I am sure the local people would appreciate the effort.

To assist you to do this here are some useful phrases: -

Good morning	Buenos dias
Good evening	Buenos noches
Good afternoon	Buenos tardes
Goodbye	Adios
How are you?	Como estas?
Thank you	Gracias
Excuse me	Perdoname
Yes/no	Si/No
I (don't) like	(No) me gusta
Where is?	Donde esta?
I don't understand	No entiendo
One, Two, Three, Four, Five	Uno, dos, tres, cuatro, cinco
It's fine	Esta bien
You're welcome	De nada
Very well, OK	Muy bien
I want	Quiero
I don't speak (much) Spanish	No hablo (mucho) espanol
Please	Por favor

Plants & Animals of Cuba

The area at the eastern end of the Hicacos peninsular was designated an ecological reserve in 1974 and is the home to a wide variety of bird, animal and plant life. In Cuba there are no poisonous animals or plants that may harm humans. There are over 8000 species of plants on the island and the forests support a wealth of flora and fauna in an extremely fertile environment.

The National bird is the Cuban Tocororo, it's feathers the colour of the National flag. The Royal Palm is the National tree, this can be seen throughout Cuba and the National flower, is the Butterfly Jasmin, coloured white and representing purity.

The Monetary System Explained

Cuban people are paid in their own currency, which is the Cuban peso. This money can only be used by Cubans in their ration shops and certain other places. Since 1993, Cubans have been allowed to use US dollars and indeed many now freely use them to buy luxury items that they would otherwise not be able to buy with Cuban pesos.

The US dollar is the currency for the tourist. An important point to mention is that I found it better to buy US dollars before leaving home, rather than exchange pounds sterling in Cuban banks or hotels as the commission rate was around 6% and back home it can often be exchanged commission free or at a lower rate.

A recent development is the partial recognition of the Euro as a currency that can now be used in some places. I suggest that for the moment it is probably better to use US dollars until the Euro is fully accepted everywhere. However should you have any Euros left from a European holiday then of course take them with you.

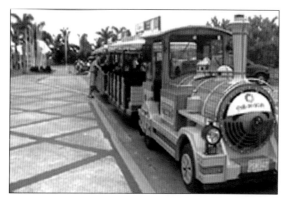

Three Modes of transport around Varadero

Plate 1
The Road Train

Plate 2
An Old
American Taxi

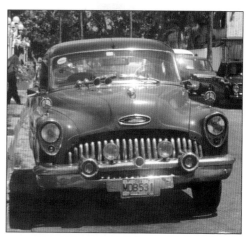

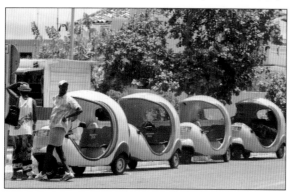

Plate 3
The Coco Taxi

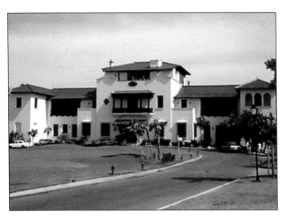

Plate 4
The Former
Dupont Mansion
now the Golf Club
House, Restaurant
and Bar

Plate 5
Varadero
Golf Club

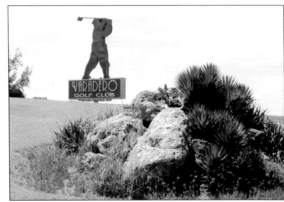

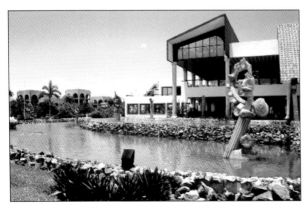

Plate 6
Plaza America
Shopping Centre

One important point to mention is that you can use British/European credit cards to obtain cash or pay for goods in Cuba, however any card linked to an American bank or company, e.g., American Express cannot be used in Cuba. This includes Abbey National, MBNA and Capital One cards. Ensure your card is valid before you visit. As a cautionary note, some restaurants do not accept credit cards so take some cash with you if dining out.

Travellers cheques can be used and this includes American Express traveller's cheques, but again the exchange rate in Cuba is low. Keep any valuable items and cash/credit cards in the hotel safe when possible to avoid any problems.

Tipping & Money Matters

This is one of the minus points on the island as the locals are quick to seize the opportunity to send a tray round, ask for or expect a tip for services. When visiting most public toilets there is usually someone at the door collecting tips.

In restaurants, hotels, streets, markets and bars there are often traditional Cuban bands playing, and it is not long before a donation is requested. Should you go on an excursion to Havana, there are people sketching you, girls in bright costume wanting to kiss the men, beggars and others who appear from nowhere all asking for money, usually one dollar.

When visiting the town of Varadero or Havana in particular, tourists are constantly asked if they want to buy cigars. I have known people who have had some excellent bargains and saved a lot of money and some who have not got what they expected. Check that what you pay for is exactly what you wanted. Many shops charge inflated prices for their cigars, so shop around!

When visiting museums or similar places you will find that some will charge for photo/video use inside. Photographing local people is fine but again they will often expect a donation for the pleasure of posing for you.

Bar tenders in many places look for tips as well as the porters in the hotels amongst others. One that the unsuspecting holidaymaker can get caught out on is at the airport. When you emerge from the airport to meet your holiday rep. to walk the short distance to the transfer coach, often someone will come to pick up your suitcases, which are whisked away before you know it. It is when you get to the coach and the man is waiting for a tip and you only have a $50 note that it becomes embarrassing. Ensure you obtain some $1 notes before you leave home or insist on carrying your own cases to the coach.

In most Cuban hotels and other businesses they are very cautious about taking $100 notes and in some cases $50 notes as there are forgeries about. It is better to take $20 notes and a good supply of $1 notes for tips.

Overall my thoughts on tipping are that you need to draw the line somewhere otherwise it can cost you a lot of dollars each day.

One final point, if you are asked anywhere for money or to buy cigars, I found that if you say no or no disturbing, then most people do not ask a second time and walk away. This is a lot better than many other countries where people will not leave you alone.

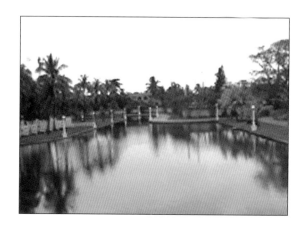

Plate 7
Two Views of
Parque Josone in
Varadero

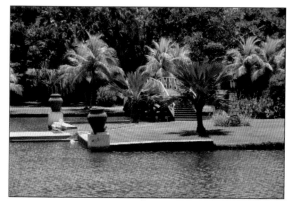

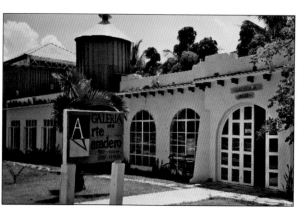

Plate 8
The Art Gallery
in Varadero

14

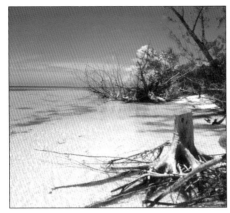

Plate 9
A view to the North East
of Varadero on the
Hicacos Peninsula

Plate 10
The famous Varadero
beach with white sand
and clear Turquoise
sea.

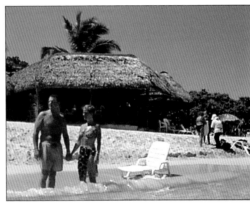

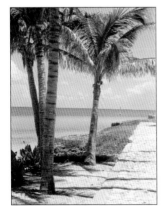

Plate 11
A View just North
of Varadero centre,
walking to the beach

Mosquitoes & General Health

At certain times of the year, mosquitoes and sand flies can spoil a holiday as the dreaded midge can in the UK. Some hotels take action to try to eliminate them by various means but you can still get bites, which can swell and cause skin irritation.

Ensure you take plenty of mosquito repellant and sting relief cream, as it is expensive to buy in Cuba. A course of anti-histamine tablets from your doctor before you leave would be helpful. Some local people who appeared to be bite free recommended rubbing your skin with lime or lemon juice as the mosquitoes do not like the acid in it, or white rum as another person stated.

There are chemist shops and medical centres in Varadero but they may prove expensive so take the items I have recommended above with you. Being prepared before you go could save you pain, discomfort and money when you get to your destination.

Regarding general health, Cuba has a health service, which is the envy of many countries. It has a doctor for around every 300 patients, the lowest infant mortality rate in the Caribbean and life expectancy in the region of 75. Should you be unlucky to have to seek medical attention while on holiday then you can expect to have good professional care, but ensure before you go that you have holiday insurance.

Should you need a doctor or hospital care, then keep all your receipts, pay in full at the time then claim it back from your holiday insurance company on your return to the UK.

Weather

Situated in the Caribbean, Cuba usually enjoys a daily temperature of between 27ºC and 32ºC in July and August and relative humidity of 81%. The coldest months by their standard are December to February.

Should you prefer dry weather then February or March is the time to go, with the wettest being October and June. Rainfall tends to be in the form of tropical showers which are very heavy but often tend to last possibly ½ hour or thereabouts.

If you prefer days with more actual sunshine then April and May are the times to visit. You can of course have variations to the above but that can happen anywhere at any time, as we all know here in the UK. As a general comment, look forward to good weather and take plenty of sun cream. The hottest part of the day is 12.00 to 2pm and many locals have a traditional siesta then so it may be wise to try to keep out of the sun during that time to avoid burning.

The hurricane season is around July to October and although Cuba has escaped hurricanes for the last few years, they can happen as they do in other countries in the Caribbean. Generally your chances of encountering one are slim.

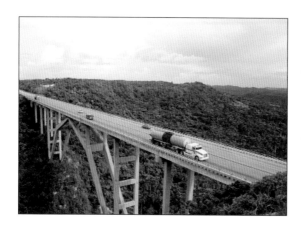

Plate 12
The highest bridge
in Cuba, between
Varadero and
Havana.

Plate 13
The Cathedral
and Square in
Havana,
built in 1777.

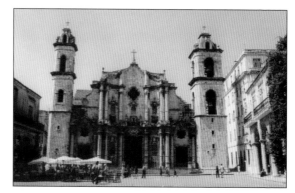

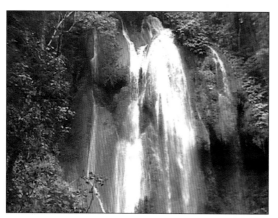

Plate 14
A waterfall on the
Rambo Tour
near Trinidad,
in the Escambray
mountain range.

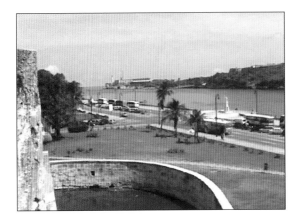

Plate 15
A pleasant view
from the Castle
in Havana.

Plate 16
One of the ele-
gant buildings in
Havana.

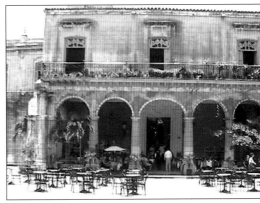

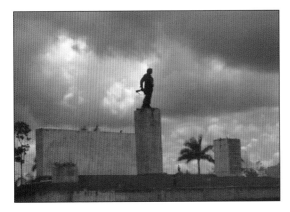

Plate 17
Under dark sky
stands the statue
and mausoleum of
Che Guevara
in Santa Clara.

Communicating with the UK

Many people who go on holiday like to send postcards back home. Whilst postcards and stamps are widely available in shops and hotels, you will find that mail takes up to two months to arrive back in the UK, so you may decide it is not worth sending them. When the postcard arrives (if at all), you will be ready for your next holiday.

Using the telephone in your hotel rooms around the world is usually expensive and Varadero is no exception, the cost of a phone call home being around $9 a minute. Even buying telephone cards from outside the hotel can prove just as expensive at $5 a minute, so you may find it better not to bother.

Should you wish to use the telephone the international code is 119 followed by 44 then the UK code minus the 0 then your number.

The hotel may have an e-mail service, which may be a lot cheaper than using a telephone, so take e-mail addresses with you, and hopefully you may have that facility.

Travelling around Varadero

In common with many towns and cities, there are numerous ways to travel around Varadero these include the following: -

Local Bus: - These are good value, taking you anywhere in Varadero for $2 on a set bus route. The bus tends to run approximately every 40 minutes and drives past most hotel entrances. Should you wish to use the bus then ask at reception or the security guard at the hotel entrance when the next one is due. There are no bus stops or set pickup points on the bus route so you can waive one at any point.

There is a new double decker open top bus service for which a pass can be bought for $2 per day and it runs from hotel to hotel and from Varadero centre.

Yellow 2 Seater Taxi: - These two seater coco taxis are bright *(plate 3),* comical, and in Varadero often driven by women. They will take you anywhere in Varadero and like traditional taxis the fare can alter depending on distance but usually no more than $10. You will find it is better to agree a price with them before you start.

Taxi: - Again the cost depends on distance but you will find a taxi outside almost every hotel and shopping area as well as bars and restaurants. As mentioned previously, agree a price before you start. You may find your taxi is an old American car *(plate 2),* or more likely one that smells strongly of diesel. Using a taxi on either out of town or a local journey, may work out cheaper if there are a number of passengers to spread the cost.

Horse & Carriage: - These can travel to hotels but basically they operate up and down the main shopping area. You can travel in style and still get some fresh air. Cost is usually $10 but negotiate. Remember they are not as fast as buses, so allow more time for your journey.

Road Train: - Varadero has a road train *(plate1),* similar to those found on promenades around the UK. It is efficient and follows the bus route, only charging $2 and giving you some fresh air as you sit in the open carriages on your journey. This and the local bus probably represent the best value for money.

Trains: - There are no trains to or from Varadero. To use a train you need to go by bus to Matanzas where you can connect to other destinations.

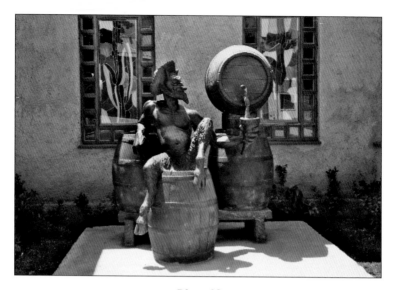

Plate 18
An unusual sculpture on 1st Ave near Parque Josone.

Plate 19
A drink and welcome awaits you in and around Varadero.

Cuba

Car: - You can hire a car and indeed many people do so. Most of the hotels can arrange this facility for you and there are a number of car hire centres in Varadero. The reality is that roads outside of the main holiday area can be in a bad state of repair with deep potholes and fuel can be in short supply in some areas. I found a shortage of road signs in most areas.

A tank full of fuel in Varadero will take you to Havana and back, which tends to be the main excursion for many tourists. Take your driving license if you intend hiring a car and check insurance and amount you pay, beforehand.

Mopeds, Scooters & Motorbikes: - These are for hire in most hotels but remember the deep potholes in the roads. You need to check any insurance carefully and ensure you are given a crash helmet and wear suitable clothing. It is generally not recommended to hire mopeds etc.

Finally you can always cycle around the area if your hotel has bicycles as part of the all-inclusive package. The peninsula is flat and suitable for cycling as opposed to walking in hot weather, which will be tiring, and too much like hard work in this tropical climate.

All Inclusive Hotels

The majority of accommodation in Varadero for tourists is in all-inclusive hotels. There are over 40 hotels in the resort which cannot all be described but I will for the benefit of those people who have not experienced the 'all inclusive', give a brief description on facilities in some of them: -

Brisas Del Caribe: - This is one of the larger hotels set in very attractive well-stocked, tropical gardens. Comprising of two blocks, north and south, the north block consists of a large reception area with two bars (one 24 hours) and seating. There is a cigar and rum shop and to keep contact

with the outside world, telephones, fax, Internet service and a post office. The reception leads onto an attractive sun terrace overlooking the main pool.

Descending a spiral staircase from reception is a large buffet style restaurant, refurbished late 2002. The meals are of a good standard with drinks available to complement the meal. Outside near the pool is another bar then further on are two smaller linked pools with a bridge over and a separate whirlpool nearby. A children's paddling area with a waterfall is also a short distance away near the kids club.

A winding path leads to a gym, massage room, two tennis courts, reflexology, sauna and bicycle hire. There are large grassed areas for sun beds as you walk between the palm trees to the beach, which has four rows of parasols shading the white powdery sand and sun beds. A very small bar is on the beach and a nautical point offering a selection of water sports for those who like to be doing something on holiday.

Also situated in the north block is an Italian A La Carte restaurant (Las Brisas) and an entertainment area and bar with the sea as an attractive backdrop. The restaurant is also a disco from 11pm-2am Mon- Sat. The other A La Carte in the north block is the La Caleta Beach Grill, open evenings only. All of the speciality restaurants should be pre-booked. Leaving the reception, you cross a bridge over fishponds, passing an excellent wedding area to reach the south block 100m further. This has a 24-hour bar, with an indoor area, doctor's room, table tennis and two further A La Carte restaurants, Fantasia and El Patio. The shaped pool is encircled with sun beds and the accommodation area. The rooms are larger in this block and it generally has a more relaxed atmosphere. It is very tastefully decorated throughout. I found the hotel very popular with UK visitors and a nice place to stay.

Iberostar Barlovento: - This hotel has a large reception area with a bar and water feature. Also located in reception are a doctor and a podology room. Cigar rolling demonstrations are given there occasionally and postcards, souvenirs and gifts are available in the small shops. An Internet service enables you to contact home.

There are two pools at the hotel surrounded by palm trees; one has a decorative fountain at the end. An outdoor chess set and small shop are nearby the pool area.

The main restaurant, La Hacienda, situated by the pool, is reached through the main lobby. A show area with a small square is adjacent to the pool. A bar beside it is open at night and it has a relaxation area, which is used for bingo and tea in the afternoon. The main A la Carte restaurant is El Cactus (Mexican) and can be booked once per week, the other is the El Rincon Cubano, a criolo restaurant serving local cuisine, and is open evenings. Both are tastefully decorated and of a good standard. Next to El Rincon Cubano is an open restaurant called El Flamboyan (ranchon grill) overlooking a small pool.

Walk through the grounds to the beach, where there is a nautical point offering various water sports and a massage area. Currently there is no beach bar.
A children's mini club is in the hotel complex to cater for the children while the adults pursue other activities like rifle shooting or tennis, which are also available at this hotel.

Coralia Club Playa De Oro: - This hotel has a large reception area on two levels with a high and somewhat unusual shaped roof over it. The hotel complex is divided into three blocks, two for accommodation and one for reception. Within the reception area is a shop and hairdressers while on the higher level is a lobby bar situated
near the main restaurant. An animation area nearby is used in the evenings for shows, which are presented to a high

standard. Just out from reception but in the same block is a gym, sauna, massage area and Internet service. A medical service is also available here should you need it.

Walking to the pool area through the attractive grounds, you find two large pools linked together with a bridge over. One pool is suitable for children. A pool bar and snack bar are open daily with a rest area overlooking the pool. Three tennis courts are available for use within the complex.

Both accommodation blocks, with lifts to several floors, are situated either side of the pool and the rooms are tastefully decorated and kept very clean. Rooms have televisions, refrigerators and ample drawer and wardrobe space.

Passing a towel and games service clubhouse near the pool you arrive at a children's playroom, supervised by the hotel staff. Passing here there is a shop selling local souvenirs and a ranchon grill bar, (La Caleta), open daily for lunches but book- able for evenings as an A La Carte restaurant. Beside it is the open-air animation area where entertainment is provided in the evening. The excellent gently sloping beach has the usual non-motorized water sports available and the animation team organizes a variety of beach activities.

One point to note about this hotel was that the beach attendants asked where you would like to sit on the beach then placed the sun lounger there wiping it clean before use, which I thought, was particularly good. Having stayed in this hotel, I found it very clean and well maintained and my stay was very pleasant. I particularly noticed how friendly and welcoming the staff were to the guests.

Sol Palmeras: - This hotel has a hexagonal reception area with seating round. This leads on to a large balcony with a piano bar and seating to one side and the main A La Carte Italian restaurant (O Solo Mio) next to it which is bookable once per week. To the other side of the balcony is a bar, and

doors leading to a large animation room with a bar used for evening entertainment. An Internet service is available nearby.

Wide stairs lead down to a lower floor and large fishpond containing many fish. On this level there are clothes, jewellery and souvenir shops along with a salon. Doctor and massage services are located in the bungalow complex next to the hotel. To one side of this level is the main buffet restaurant, La Panchita, open daily for breakfast, lunch and evening meal. This restaurant has an extensive choice and is attractively designed.

Walking through the attractive grounds you come to another A la Carte restaurant El Caribeno, bookable for evenings but used at lunchtime as a barbeque restaurant. A clubhouse with towel service and games/equipment hire is near the pools. Next are the two shaped pools, one encircling the pool bar with the other next to it. Two bridges cross the pools and a small children's pool is nearby. At the far side of the pool area is a snack bar for fast food and drinks with a rest area beside it.

On the beach you find a beach bar and small snack bar along with a variety of watersports equipment available for use. Nearby is a rifle range and tennis courts for those who want more. A mini club and children's play area is just off the beach and gives a welcome break for parents.

This hotel has a wide choice of bars, restaurants and snack bars and is very attractive with extensive grounds. Within the grounds are a bungalow complex spread over a wide area and another A la Carte called Oshin Chinese restaurant, which is again bookable each week. I stayed in this hotel also and found it to be of a very high standard.

Iberostar Tainos: - This hotel is one of the newer ones situated 13km from the town centre. It has a reception area, recently enlarged at the end of 2002. There is an attractive spiral staircase with a water feature around it. A bridge leading out from the water feature into the grounds gives access to an accommodation area and restaurants. There is a bar in reception and near it the lifts to another accommodation area. An Internet service and snooker area is also near the bar.

This hotel houses 136 people in the main block and 136 people in bungalows which are situated in the grounds and are very bright and attractive and of a high standard. The grounds also have two tennis courts, a gym and football area. There are shops adjacent to reception and crafts are on sale outside the main restaurant.

The hotel has one main pool, which is shaped, and quite attractive with a bridge over it. A small pool is provided for the children nearby. There is a towel service available. A small snack bar is near the pool and a ranchon grill which is open all day and evenings for A la Carte creollo food.

Similar to the other hotels there are shows presented each evening, organized by the animation team. These take place in the entertainment area next to the restaurant. Within the grounds is a mini club/babysitting service, to give that extra break for parents.

Walking to the beach you will find a beach bar and rest area and a variety of non-motorized water sports available nearby with dancing/aerobics lessons daily on the beach and around the pool area.

This hotel, although smaller than others, was very clean and new looking but still provided a good service to the holiday-maker, in a relaxing and enjoyable environment. The palm trees and other plants in the grounds, although smaller than more established hotels, are maturing yearly but still give that tropical feel!

To many people an all-inclusive is a more convenient way of taking a holiday in a far away place. They usually include all your drinks, which tend to be lager, soft drinks and a wide range of cocktails. The cocktails are made from locally produced spirits and are generally good.

Should you sample the cocktails then no doubt you will find that the pouring of spirits is very liberal and the alcohol strength great? Need I say more!

Meals, whether snacks, A la Carte or in the general restaurant are included. Many take the form of buffets. Most hotels have food and/or drinks available 24 hours a day.

Many hotels operate a towel service where you leave a deposit for a beach towel when you arrive. During the week you can exchange it when soiled for a clean one when necessary, then before you leave the hotel, hand in your towel to reclaim your deposit.

On the beach you will find a range of items available for use, usually including kayaks, pedaloes, snorkelling equipment and windsurfers. There may be other items but these vary slightly between hotels.

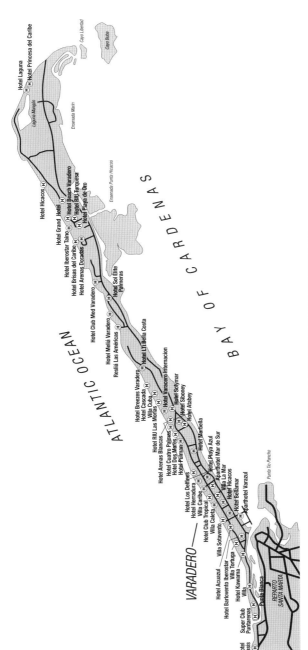

HOTELS ON THE HICACOS PENINSULAR

Entertainment Day/Evening

Most of the hotels provide entertainment both on the beach and around the pool area on a daily basis. Most evenings the hotels tend to organize a show for the residents of the hotel.

Should you want other entertainment then there is a cinema in Varadero located on Avenida Playa and Calle 42. Do not expect to see the latest blockbuster, as the films are generally a few years old before they reach Cuba and tend to be only Spanish movies.

Other entertainment available during the evening consists mainly of live local Cuban bands singing at various locations around Varadero, (see section on Bars etc). You can usually sit and relax over a drink while listening to the music and sometimes have the opportunity to dance Latin American style to the sounds.

Shopping

Around the shopping area in Varadero there are a number of small markets as well as some shops, though few in number. The Plaza America shopping centre *(plate 6)* near the Melia Hotel has more shops as does the Palma Real and Caiman centres opposite the Cuatro Palmas Hotel, but not the large number of shops that we know and are accustomed to in the UK.

Shopping in Varadero is slightly better than other towns but do not expect to buy the latest fashions. The clothes available generally tend to be expensive, along with watches and films for cameras, so buy yours before you visit Cuba.

Markets in Varadero and Havana tend to sell mainly arts and crafts in the form of carved wooden figures/ornaments, paintings, leather goods or musical instruments e.g. bongos and maracas. There is very little difference between stalls in any market, so you do not have a wide selection of goods to choose from.

Many people will ask if you want to buy cigars, check the prices if possible before you leave home and also in the Cuban shops and negotiate bargains, do not rush to buy but look at quality, freshness and price before you buy.

You can get good prices on some alcohol but you are only allowed to bring a small quantity back to the UK so that will not use a lot of your spending money.

General advice would be to have a good look around all the shops first before deciding what to buy. Tourist shops are open from 10am to 6pm/7pm with food and other shops selling essential goods opening from 9am to 5pm/6pm.

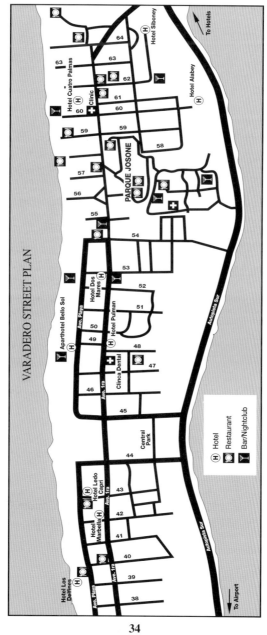

VARADERO STREET PLAN

This street plan should be used when referring to restaurants, bars etc in resort information.

Services Guide

Markets: - Calle 12, Calle 46, Calle 54,

Dental Clinic: - Calle 48/1st Ave

10 Pin Bowling:- Behind Calle 42, Calle 54/ Near Autopista

Art/Pottery Centres: - Galeria de Arte/Ceramica
Near Calle 59 on 1st Ave
Galeria de Arte Calle 34/1st Ave

Medical Centre 24 hour: - Clinica Int. Calle 61/1st Ave

Chemists: - Calle 61/1st Ave, Plaza Americas,
Hotel Brisas Del Caribe, Villa Punta Blanca

Photo Shops: - Photo express Calle 41/1st Ave,
Photo Service Calle 44, 24 and Ave Playa
Centro Commercial Calle 63

Cigars & Rum: - La Casa de Habana Calle32/1st Ave
Casa Del Habano * Calle 63/1st Ave

Museum: - Municipal Varadero Calle 57, near beach

Parks: - Parque Josone * Calle 59/1st Ave
Parque Central Calle 45/1st Ave
Parque de las taquillas Ave Playa/1st Ave

Marinas: - Marina Gaviota, Hicacos Peninsula
Marina Chapelin, opposite Hotel Coralia Club
Marina Puertosol, Darsenas, Varadero

Taxis: - Cubataxis Tel.613674 / 612845
Taxi Gaviota Tel.612620
Taxi transtur (airport) Tel.612133 / 613066
Cubanacan (in hotels) Tel. 611616

Cinema: - Ave. Playa. (Probably in Spanish)

Golf: - Varadero Golf Club*, Ave Las Americas. Tel 667388
Mini Golf, Calle 42/1st Ave

Rent A Car: - You are able to rent a car from all hotels
(see section on travelling around Varadero).

Fuel Stations: - Autopista/Calle 17
Autopista/Calle 54

Bus Station: - Autopista/Calle 36

Banks: - Banco Financiero International. Calle 32/1st Ave
Casa Del Habano Calle. 63/1st Ave
Plaza America Centre. Carretera Punta Hicacos

Post Offices: - Calle 64 and 1st Ave (main P.O.)
Ave Playa between Calles 38 and 39

Tourist Information Centre: - Calle 23/1st Ave Tel. 666666
Open 8am to 8pm

Bars, Restaurants & Night Clubs

Each hotel has a number of bars and restaurants of their own but it is always a welcome break to visit other places in the area and to explore the town's culture and nightlife. To help you find your way around, refer to the street map. I have given below a list of what myself and others consider some of the best bars and restaurants in Varadero. A number of them have music in the form of Cuban bands with their vibrant sounds and rhythms or are traditional Cuban pubs or restaurants serving typical local dishes. Visit and see for yourself. They are arranged in street order so you can work your way through!

KiKi's* – Pasta Restaurant. Calle 5/1st Ave
Castel Nuovo- Italian Food. Calle 11/1st Ave
Arrecife – Sea Food Restaurant. Calle 13/1st Ave
Mi Casita – Restaurant on beachfront. Calle 13-14
La Taberna – Small restaurant just off Calle 13
Bennys - Bar. Live Music just off Calle 13
A Cluster of small, local restaurants near the beach on Calle 13
FM 17 – Bar with live music/ Rum on table. Calle17/1st Ave
Local Cuban Restaurant on corner. Calle 18/1st Ave
Small Cuban Bar, Live Music, evenings. Calle 18/1st Ave
Lai Lai* – Chinese Restaurant Calle 18/1st Ave
El Criollo - Cuban Food. Calle 19/1st Ave
El Toro – Steak House, chicken on skewers. Calle 25/1st Ave
La Colmena – Restaurant. Between Calles 25-26/1st Ave
FM 27 – Local Bar. Calle 27
Guamaire – Local Restaurant. Calle 27/1st Ave
Caracol – Bar. Calle 27/1st Ave
La Casa de Habana – Restaurant. Calle 32/1st Ave
La Guantanamero – Restaurant. Calle 36/1st Ave
La Vecaria – Cuban Food. Calle 39/1st Ave
El Caney – Restaurant. Calle 40/1stAve
Dante* – Italian Parque Josone Calle 56/1st Ave

Albacora* – Sea Food, Live Music. Calle 59 on beach.
Castel Del Queso – Cuban Fondue Restaurant. Calle 62/1st Ave
Bar 62*– Bar with Live Music Sat-Sun. Calle 62/1st Ave
Canamare – Restaurant* Crocodile steaks etc. 1st Ave
Dupont Mansion*– Bar/restaurant* behind golf course,
(plate 4).

Recommended Night Clubs/Disco's: -

La Bomba – Hotel Coralia Club
Club Darsena – Near Marina Puerto Sol
Mambo Club – Gran Hotel* Dancers/Orchestra
La Rumba Disco – Near Hotel Bella Costa
La Bamba – Hotel Tuxpan
Havanna Club – Calle 62

The nightclubs generally open 11pm-4am but may vary
between clubs. Entry charge tended to be around $10 and
included all drinks but this may vary slightly.

There are many other bars, restaurants and nightclubs, too
numerous to mention so the recommended ones only are
shown.

Those highly recommended are shown with *

Beach & Sea

The most important part of a holiday, along with the weather for many people is the beach and the sea. Varadero beach consists of virtually white sand for the 12½ mile length of the Hicacos Peninsular apart from a few small headlands. The water is warm as you would expect in this part of the world and often in late afternoon the shallow water is positively hot. The Gulf Stream, which passes by, ensures a high water temperature is maintained.

The beach slopes gently to the sea, which is safe to swim in, and there are lifeguards at many hotels operating a green flag system to ensure safety in the water, which is very clean, and of turquoise appearance. Varadero has some of the cleanest beaches in the world.

You can walk on most of the palm tree lined beaches. Hotels tend to put thatched parasols on their sections of beach for residents use; you are free to walk along, but not to stray into other hotels.

Places to Visit

There are a number of excursions available from Varadero to local events and to locations in other parts of Cuba. Whether you book these trips with your tour rep., in the town or in your hotel, the price seems to be fairly constant. When considering any booking it is worth noting that trips organized by your tour representative have been fully checked for safety and comply with safety regulations.

It is recommended that tourists do not book any flights or excursions involving Russian helicopters or aeroplanes as the safety record of some of these aircraft are not good.

Local Trips: - You have an opportunity to swim with the dolphins or watch them; there is sea fishing, sub-aqua diving* and snorkelling trips. One of the trips I can recommend is the Jungle Tour*. This trip is a high-speed boat ride through the mangroves before you stop for a visit to a small zoo/wildlife reserve. Here you can see crocodiles, Iguanas and other animals before heading back to base. It is a good 2 hours adventure. The jungle tour, fishing and diving depart from Marina Chapelin, which is situated, on the Bay of Cardenas opposite Hotel Coralia Club Playa de Oro.

Another excursion worth participating in is Snuba Cuba*. This is similar to snorkelling but with a longer snorkel. A harness and regulator are connected to a 7metre hose and air tank, enabling you to swim underwater. This takes place in the Bay of Pigs and lasts a full day.

A trip that is very popular is the Jolly Roger catamaran cruise*. This is a relaxing day spent swimming, sunbathing and snorkelling with lunch and an unlimited bar included.

One place I recommend you visit is Josone Park* in Varadero (plate 7) on Calle 51/1st Ave. Originally designed as a country retreat and completed in 1942, this park with its restaurants, lake and well-maintained grounds are exceptional. The parks name is made up from the first three letters of the original owners names: Jose and his wife Onelia. You may see the pet Iguana near the open-air swimming pool at the far side of the park. Take time to admire the view from the arched bridge over the water as you walk through the park and do not forget to take your camera.

Another place to visit is Al's house*, a restaurant, which is currently closed in 2002 for refurbishment. Al Capone once owned it until the revolution. It is situated not far from the bridge to the west of Kiki's Club*. The view of the sunset from this point should not be missed. Mansion Xanadu*or the Du-pont Mansion, as it is known (plate 4) is well worth visiting. Originally the home of Irenée Dupont, the French Millionaire, it is decorated in 50's style. Have a meal on the terrace during the day and in the evening cocktails are served upstairs whilst you listen to live music and watch the sun go down. The mansion is situated behind the golf course near the Plaza America centre.

Near the eastern end of the peninsular are the Ambrosia caves which were discovered in 1961. A guided tour is available and you can admire the cave drawings as you walk around them. These are open Tuesday to Sunday until 4pm. An ecological beach is there and many people visit for picnics. Signs are situated near the main autopista and there is an entry charge.

Situated on Ave. Las Americas is a former water tower on San Bernadino Hill, the highest point in Varadero overlooking the autopista. This has an interesting sculpture of Don Quijote on a donkey*, and is near the small restaurant of Meson del Quijote. You could walk from the east end of the town near Calle 64 or you can take a bus or train for the short distance.

The church of Santa Elvira built in 1938 stands on the corner of Calle 46/1st Ave. in Varadero, it is a sturdy building of Mexican appearance. The church is used regularly and is worth a visit.

A small fairground is situated near Parque Josone on Calle54/autopista. Here the children can enjoy the thrills of the fair while the adults look for a bargain in the small shopping complex nearby.

One -Two Day Excursions: - These are available to Trinidad, Bay of Pigs and in particular Havana. Two trips I found interesting and enjoyed was the trip to Havana including a visit to the famous Tropicana Show*. This show with over 100 dancers was excellent. An overnight stay in a nearby hotel was followed by sightseeing in Havana the next day before returning to Varadero *(plates12,13,15,16)*.

The second trip was the 'Rambo' Tour*, a visit to the Cuban rainforest* in the Escambray Mountains. This included a walk along a shallow river with swimming in the large mountain pools. The walk through the rainforest to the waterfall *(plate 14)* was particularly good but even more interesting was the ride in the old Russian truck to get to our starting point. Again we stayed in a hotel in the forest overnight before visiting the towns of Trinidad* and Cienfuegos on the return journey. If you can 'rough it' a little then you will enjoy this one!

Both these trips, although a little on the pricey side, did in fact prove good value for money as they included all meals.

Sport in Varadero

Many of the hotels have their own tennis courts and of course swimming pools. Some have gymnasiums and saunas as well as a range of other sports.

Generally from the beaches you have an opportunity to go parasailing, banana boat riding and water skiing as well as playing the usual volleyball on the beach. You can snorkel from the beach although most sea life can be seen over rock and coral. Many hotels offer a free diving (taster) experience in the hotel swimming pool and the opportunity to go diving in the sea, under supervision, with a qualified instructor. Should you want further diving training or qualifications you should contact Barracuda Diving on Calle 58 or at Marina Chapelin for further information.

In Varadero there is The Las Americas Golf Club *(plate 5)* one of the few 18-hole par 72 golf courses in Cuba where you can play a round of golf on an excellent course.

Bicycles can be borrowed from most hotels and you can cycle the area, which is virtually flat, does not have a lot of traffic and is fairly safe as long as you watch for potholes in the roads.

The Cuban people play and watch baseball, which is their national sport; they also like football and swimming. You will find that you are generally well catered for in the sports department in Varadero although you may not feel like doing any sport because of the heat.

Resort Summary

The resort of Varadero is very clean and the people are extremely friendly and helpful both in the town and in the hotels.

The beaches are very clean, being cleaned with a machine early each day. The sea is clear and very safe to swim in. Lifeguards were present on the beaches at most hotels.

I never saw or heard of any crime while there and found it safe to walk out at night, and indeed many people were in the town and at nightclubs late at night.

The shops were few in number compared to the UK and there was not a large range of items to buy either in the shops or the markets. Many of the items on sale appeared cheap and tacky.

The hotels generally served good food in hygienic conditions. Although I could not visit all the hotels in Varadero, I did not hear of anyone complaining about the standard of hygiene in the hotels or in the restaurants in the town.

Wherever you go you will see musicians especially in restaurants, bars and hotels who all want tips for singing, as do many other people for the smallest service rendered. This was a lot easier to manage here than in most other countries. Just say no and they usually go away. You need to know when enough is enough!

Excursions were very good, particularly the Havana overnight trip and the Rambo Tour. The local Jungle Tour was very good too. The trips though at first seeming a little on the expensive side, proved to be good value for money.

Depending on the time of year, you may be troubled with mosquitoes, but you could be in any country. You need to take sting relief and mosquito spray with you.

Do not use a telephone to phone home, as it is very expensive. Postcards take at least two months to arrive home. Best bet is possibly e-mail if your hotel has that facility and you are desperate to keep in touch.

Travelling around Varadero is easy using taxis and horse and carriage. Best value is the local bus and road train. Travelling outside Varadero area independently can be more of a problem.

The weather, although generally very hot and sunny most of the time, can change as it can anywhere. Even when cloudy it is often humid.

Vaccinations recommended (this may vary): -
Polio, Typhoid, Hepatitis A, Tetanus.

Visa Requirements: -
A tourist card is needed to enter, along with a passport. Some holiday companies include the price of the tourist card in your holiday. Ask when you book. Should you make a mistake when completing your tourist card, it will cost you £10.00 to replace!

Taxes: -
Each person must pay $20 departure tax at the airport. This must be in US dollars.

Electricity: -
Continental and US 110v or 220v flat 2 Pin sockets mostly in hotels, but some with round pin. Remember to take your adaptor.

Time Difference: -
-5 Hours GMT

Flight Times: -
8½ -11 hours depending on wind direction.

Banks/Exchange in Varadero: -
You can exchange money in most hotels as well as banks. The commission rate is usually about 5-6%

Returning Home

Before returning home, if you have any toiletries, i.e. toothpaste, shampoo or soap left over, rather than take it back home with you, try giving it to some of the local people. As these items are in short supply in Cuba, you will find the locals will welcome them with open arms.

Sooner or later the holiday must come to an end and you depart for the airport. Varadero airport or Aeropuerto Internacional de Varadero as it is known is about 30 minutes journey by coach from the hotels. On entering the airport there is the usual queue to book in, have cases weighed and collect boarding cards. Ensure your cases are not overweight as these are checked carefully.

Your next stop is opposite the check in; here you pay your $20 departure tax. Now you are free to go through to the departure lounge. In the duty free shops you will find a small display of perfumes. I found the prices higher than UK prices.

The spirits section had some items like white rum at a higher price than in Varadero shops but other bottles of dark rum were marginally cheaper. Cigars were more expensive in the airport than in Varadero.

I suggest you would be better buying any cigars and alcohol in Varadero and negotiating your own prices. You would benefit from buying perfume back home, on the aircraft or in the duty free before you leave the UK.

Hopefully this guide has been of help to you. Should you have any information you feel should be included in the 2nd edition of this guide then please e-mail Challenge Publications giving details. The author will acknowledge your correspondence.

Finally

Given the chance I would visit Cuba again as I found it an excellent country with interesting people, culture and architecture, especially in Havanna. I hope you enjoy your visit as much as I did!

Notes